Moche Pottery From Peru

Moche Pottery From Peru

George Bankes

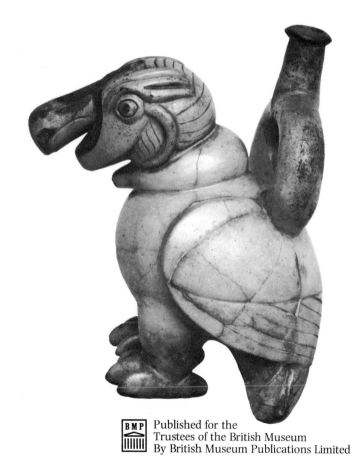

BMP Published for the
Trustees of the British Museum
By British Museum Publications Limited

© 1980, The Trustees of the British Museum
ISBN 0 7141 1558 4
Published by British Museum Publications Ltd
6 Bedford Square, London WC1B 3RA

British Library Cataloguing in Publication Data
Bankes, George
 Moche pottery from Peru.
 1. Mochica Indians – Pottery
 I. Title II. British Museum
 738.3'0985 F3430.1.M6

Designed by Harry Green
Set in 10 on 12 point Photina by
Filmtype Services Limited, Scarborough

Printed in Great Britain
at the University Press, Oxford
by Eric Buckley
Printer to the University

FRONT COVER
Figure vessel in the form of a kneeling warrior with
a club in his right hand and a shield on his left
forearm. His helmet would have been padded to
withstand club blows. He is wearing a short
sleeved tunic.
P. 1. Ht. 21 cm.

BACK COVER
Stirrup spout bottle depicting a man wearing a
cloth head-dress with geometric designs. The dark
colour of the face may represent solid face paint.
The earrings are tubular plugs.
1947 Am. 16. 12. Ht. 32.4 cm.

Contents

Acknowledgments

I wish to express my thanks to the staff of the Ethnography Department of the British Museum for their help in preparing this handbook especially Malcolm McLeod, Elizabeth Carmichael, Penny Bateman, Rod Kidman and Margaret Cooper. Also I wish to thank John Barrow for his photographic work which appears on pages 12, 18, 19, 31, 39, 40, 43, 52–4. Photographs on pages 9 and 46 are by the author.

Introduction

The earliest inhabitants of Peru came from North America by way of the isthmus of Panama. On present evidence this first migration from North America could have taken place as early as 23,000 years ago. The earliest signs of the first Peruvians have been found in the Ayacucho Basin in the central highlands of Peru. The tools of these early people included flake choppers, mostly made from volcanic tufa, but there were no arrow or spear points. Associated with these tools were bones of extinct animals like sloth, together with what may have been deer bones.

In the period from 2500 to 1000 BC there is evidence for the establishment of permanent settlements along the coast of Peru. The people in these settlements did not appear to use pottery until about 1800 BC on the central coast and 1500 BC on the north coast. Buildings were generally in stone, *adobe* (mud-brick) and packed clay. Burials were made in cemeteries set apart from the settlements and the bodies were often wrapped in many layers of cloth accompanied by elaborate grave offerings. The remains of much sea food have been found in the refuse deposits of these people so that they seem to have been primarily shore-dwelling fishermen.

Up to about 1000 BC the cultures of ancient Peru tended to be regional. At this time people lived in villages, some attached to important temples, and they cultivated maize, made pottery and used the heddle loom. From about 1000 to 800 BC the Chavín art style, particularly in pottery, spread over much of northern Peru. This influence, deriving ultimately from the temple at Chavín de Huantar in the north-central highlands, was especially felt in north coast valleys from Lambayeque in the north to Casma in the south. The north coast version of Chavín has been termed Cupisnique, after the small valley of that name just north of Chicama, where coastal Chavín pottery was first identified by the Peruvian archaeologist, Rafael Larco Hoyle. A typical feature of Cupisnique art is an incised design depicting a being with fangs protruding from the mouth, shown on stone carvings at the temple of Chavín itself. Between a thousand and fifteen hundred years after the Chavín fanged being appeared on the north coast the Moche people again depicted him in a slightly modified guise on their modelled and painted pottery. In addition, snakes are frequently shown in Chavín art, often emerging from the head of the fanged being.

As the influence of Chavín declined, the valleys of the north coast of Peru began to develop cultures with more distinctive regional characteristics. None of these people had a writing system or used wheeled transport and it was left

7

to the Spaniards to introduce these to Peru in the sixteenth century. Geographically this north coast area forms a desert plain, ranging from a few miles to about a hundred miles wide, which is crossed by rivers rising in the western slopes of the Andes. Rainfall is infrequent and the main source of water is from the rivers, which have a seasonal flow, and sea fogs.

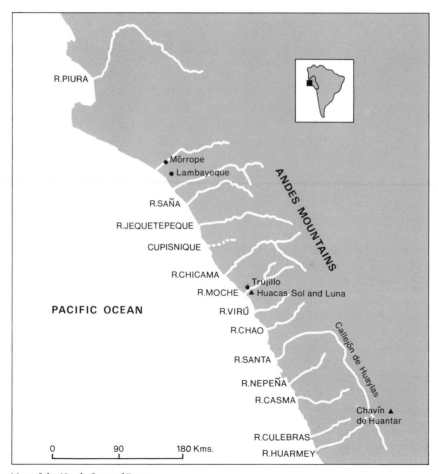

Map of the North Coast of Peru.

The Moche Culture

The first methodical work on the Moche culture was carried out by Max Uhle, a noted German Peruvianist, at the turn of the century. He excavated in the ruins of Moche, near the modern city of Trujillo, and succeeded in showing that the two large adobe pyramids, the Huaca del Sol and Huaca de la Luna, were contemporary with the modelled pottery, usually painted in red and

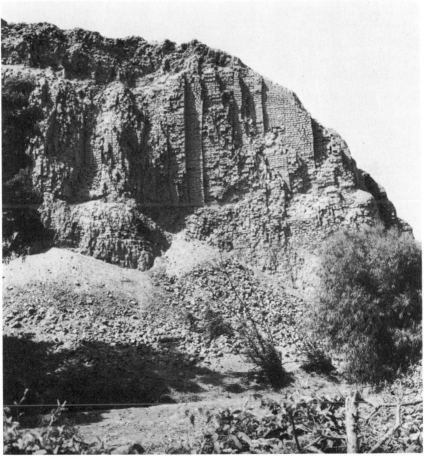

North side of the Huaca del Sol, one of the principal Moche structures. This section has been considerably eroded by Spanish treasure hunters who diverted the Moche river.

white with black occasionally added, which he classified as 'Proto-Chimú'. He made the important point that these people had a culture which had long disappeared before the Incas had appeared on the north coast of Peru.

Uhle's 'Proto-Chimú' culture was later renamed 'Early Chimú' by the American scholars Kroeber and Means, but over the last thirty years the term 'Mochica' has been widely used instead of the two earlier names. Over the last ten years or so Peruvianists have tended to use the term Moche, after the name of the modern settlement near the Huacas Sol and Luna, instead of 'Mochica' since they felt it was more accurate to name the culture after the place where it was first identified. This fits in with the terminology for other Peruvian cultures such as that of Nazca, centred near the modern town of Nazca.

Recent excavations on the Huaca del Sol by the Chan Chan-Moche Valley Project of Harvard University have shown that this pyramid underwent a long building process that stretched over several centuries, since the mound shows evidence of at least eight major reconstruction stages before reaching its final height and form. In its final building stage a grave containing an adult couple, about thirty Moche IV style pots and a butchered llama was discovered. This llama sacrifice could have had religious significance since later on, in Inca times, llamas were sacrificed as part of religious ceremonies. The exact function of the Sol is unknown, but it could have been a sacred burial mound where occasional religious ceremonies were performed. The name 'Huaca del Sol', which can be translated as 'Shrine of the Sun', derives from Spanish colonial times and does not mean that it was used primarily for sun worship.

In contrast to the Huaca del Sol the Huaca de la Luna has not yielded burials and the floors on its three platforms were kept free of rubbish. The walls of the rooms and courts on top of the Luna were often decorated with polychrome murals depicting anthropomorphic and zoomorphic beings, some of which are also found on Moche pottery. The Luna, therefore, seems to have been reserved just for ceremonies. The name, albeit a Spanish one, means 'Shrine of the Moon', which is more plausible since scenes on pottery show that the moon was important for the Moche people.

The settlements of the Moche located by recent archaeological work have generally been outside the modern irrigated agricultural land. One common form of settlement is a group of houses with stone walls, set on terraces on the lower and middle slopes of mountains lining the sides of the coastal valleys. There is at least one example of a group of houses built along the line of a road, strung out rather like ribbon development in England along some main roads. Modelled Moche pots show houses with a doorway but no door and slits for windows since glass was unknown in pre-Spanish Peru. A light curtain may have served as a door.

The food supply of the Moche consisted of several cultivated crops; maize, the staple, was supplemented by fish, mussels, wild deer and certain delicacies such as land snails. Scenes painted and modelled on pottery show fishing and hunting being carried out while excavations in Moche houses have yielded remains of maize cobs, mussels, land snails, bird and mammal bones. Guinea pig bones and dung have been found inside Moche houses which suggests that

they were kept to eat up the kitchen scraps, just as modern Peruvian Indians do in the highlands. The Moche cultivated the valley floors and some lower parts of hillsides by systems of aqueducts and canals which can still easily be seen on the ground. In the Virú Valley it has been estimated that the Moche period irrigation canals watered an area 40% greater than the present area, supporting a population about three times as large as that of the present day. Finds of Moche pottery and wooden objects in *guano* (dung of sea birds) deposits on the Macabi Islands suggests that guano was used to fertilize the land at this time.

The Moche pottery in the British Museum collection probably all came from graves. It was the custom among the Moche, as among other ancient Peruvian peoples, to place pottery and other possessions in their tombs. Some idea of Moche burial practices can be obtained from the cemeteries excavated by Max Uhle at Moche. Here some tombs were lined with adobe bricks, and several had cane roofs, while others were just oval pits dug in the ground. Some tombs contained large numbers of pots (one had 75 vessels in it) while in others only one or two were found. The number and quality of pots placed in a tomb may have indicated social standing, with the rich and perhaps powerful having large numbers of high quality vessels while the commoners only had a few mediocre ones. Usually the skeleton is found in an extended position and aligned more or less east-west with the head facing towards the east. Evidence for sacrificial burial has been found in the Virú Valley where a tomb yielded an old man together with the distorted skeletons of two women and a boy who all appear to have been sacrificed when the old man was buried. Although none of the British Museum Moche pottery collection has precise grave associations the Van der Bergh collection, comprising some 250 vessels, almost certainly came from the Chicama Valley. This collection is reported to have come from 'a single tumulus some three miles in extent' which almost certainly would have included more than one cemetery to judge from archaeological evidence.

In spite of the lack of exact provenance data for much Moche pottery, the life of the ancient Moche can be partially reconstructed from scenes painted or modelled on the pottery. Moche artists showed great interest in the world about them and provided realistic representations of plants and animals. Wild plants included cactus, still very much part of the north coast desert, while food plants such as maize and potatoes were featured in painted and modelled form. Birds included the pelican, muscovy duck and owl, and mammals the llama, deer and guinea pig. Sometimes animal and human features are shown in combined form. Hunting scenes show deer being killed with light spears or even stones. Fishing was done with nets from little canoe-like boats known in modern Peru as *caballitos del mar* ('little horses of the sea'), which were generally paddled by one man sitting with his legs astride as if he were riding a horse. Warriors are frequently the subject of Moche potters and are usually shown with their club and shield. Fighting consisted mainly in hitting the opponent, preferably on the head, with the club and then dragging him off by the hair. Prisoners were stripped naked, a rope placed round their neck and their hands bound behind the back.

11

Some indications of religious practices can be found on decorated Moche pots. A number of scholars have interpreted the fanged being revived from Chavín times as the principal Moche god and have referred to him as '*Ai-apaec*' although there is little evidence to support this claim. Certainly the fanged being appears not only with maize but also as a snake with ears and a two-headed puma, with the second head being in place of the tail. In cases where the fanged being has mainly human features but with fangs protruding from his lips he may be a priest dressed up in, for example, a puma skin, with artificial fangs added rather like the masked dancers of *La Diablada* in present day Bolivia. Finally, the Moche appear to have believed in an after-life since some modelled vessels show skeletons dancing round and occasionally playing pan pipes.

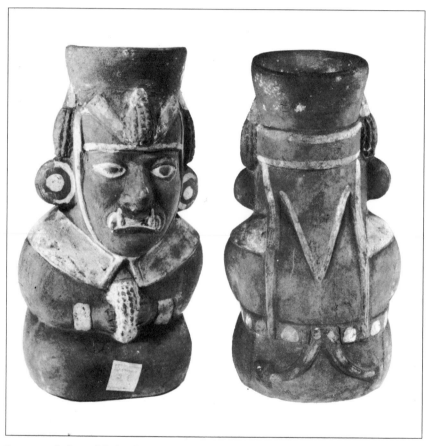

Figure vessel of a modelled and painted fanged being holding a maize cob and with three others in his head-dress. His ear spools indicate that he is of high rank. He could be interpreted as the Moche maize god, shown here in human form. The rear view shows two snakes emerging from his belt. Snakes occur quite frequently in Moche art but their significance is not known. Their association here with a fanged being suggests a connection with Chavin art. + 2777. Ht 19 cm.

Dating Moche pottery

Moche pottery can be dated in terms of a relative time scale which has been established for this style. Five phases, based upon changes in the shape and design of decorated and modelled pottery, have been distinguished and reflect the gradual development of the Moche pottery style over at least six to seven hundred years. For the beginning of the Moche style there is a radiocarbon date of 873 BC \pm 500 years from a layer of ash mixed with bone associated with Phase I Moche pottery under the Huaca del Sol. Therefore, in spite of the large standard deviation on this date, one could say that Phase I Moche pottery was being made just before the beginning of the Christian era. For the latter part of the style, corresponding to Phase IV, there is a radiocarbon date of AD 656 \pm 80 years from a textile in the grave of a Moche child in the Virú Valley. By about AD 700 to 800, in the fifth phase of the Moche style, pots showing the influence of the Huari culture appear in the same tombs as some Moche V vessels. At least one Phase V pot has been found with a Moche style stirrup spout bottle and it had Huari type polychrome decoration around its upper part. This fifth phase seems to have coincided with the expansion of Huari influence from the south which some scholars have interpreted as an invasion by the Huari people. Recently a radiocarbon date of about AD 900 has been obtained from Galindo, a Moche V site in the Moche Valley. Therefore one can date the earliest Moche pots as being made just before the time of Christ while the latest ones were being made in the ninth century AD.

Moche potters seem to have been heavily influenced by earlier north coast pottery styles. The stirrup spout bottle, consisting of a chamber with a hollow handle and spout set on top in the form of a stirrup, and the dipper, a saucepan-shaped pot with a closed top, both first appear in Cupisnique times, and these forms continue to be made in the Moche period. Certain Cupisnique techniques such as relief modelling and brush painting were used and developed by Moche potters. A number of Cupisnique period sites on the north coast were reoccupied by the Moche so that it is quite likely that the latter were in first-hand contact with the sherds and whole pots of the Cupisnique style. The Cupisnique style gave way in turn to that of Salinar in which the stirrup spout bottle continued in use. Salinar potters covered the surface of some of their vessels with a slip (a suspension of clay in water) as a foundation for the main design in the same way as the Moche did later on. Salinar style pottery gave way to a negative painted pottery style, termed Virú or Gallinazo. Negative painting is achieved by forming a positive design or figure in a resist substance, such as a clay mixture, on a red or light-coloured pottery surface. After firing the positive design is removed to leave an image underneath in the same colour as the original clay while the area around is blackened. Another negative painted pottery style is that of Recuay in the Callejón de Huaylas, the upper Santa Valley, which has some designs identical to those found in a positive technique on some Moche I vessels. Therefore there seems to have been some overlap between the negative and positive painted pottery styles in this area of north Peru.

The Technology of Moche Pottery

The exact sources of clay for making Moche pots are not known although modern potters near Trujillo obtain clay from the side of certain small ponds. It is quite likely that the ancient Moche got their clay from a similar local source. The possibility of travelling potters, who carried their clay with them and made pots to order, should not be excluded. An American archaeologist, Christopher Donnan, has recorded an example of a modern potter who collects his clay, usually kaolin, in the Callejón de Huaylas and travels down the Santa Valley making pots to order at the various settlements en route. The modern potters use donkeys or mules to transport their clay while their pre-Spanish ancestors would have used llamas.

Manufacture

Often it is difficult to say how a pot was made simply by looking at the finished product since many of the processes of manufacture may have been erased. Radiographic analysis has been done on some of the British Museum stirrup spout bottles and experiments in the manufacture of stirrup spout bottles have been carried out in the United States. In particular Donnan studied the techniques of manufacture, including firing and decoration, of Moche vessels in the collection at the Lowie Museum, Berkeley, at the University of California. Donnan lists four basic techniques used in the building-up process of Moche pottery: moulding, coiling, stamping and modelling.

Moulding

Moulding seems to have been used in the production of almost all Moche vessels although few moulds are found in museum collections as they were not normally placed in graves. Donnan suggests that moulds were made from existing vessels by pressing the clay around the pot and dividing it into two halves which could be removed as they began to dry. Also moulds could have been formed from an object such as a shell or an ear of maize.

All the moulding of Moche vessels seems to have involved pressing moist clay into the moulds rather than pouring in a liquid clay slip. Donnan found that as the clay began to dry it shrank away from the inside of the mould and was easily removed. He pointed out that the inside of the mould need not be treated artificially to prevent the clay from sticking to it.

Two-piece moulds were most commonly used for making pots. In particular this type of mould was used for making the chamber portion of stirrup spout and double-chambered whistling bottles. The small figures such as the heads

added to vessels for ornamentation were formed in two-piece moulds. Non-stirrup spout pots made with two-piece moulds included the chambers and mouths of jars and dippers.

One-piece moulds were also used to produce both halves of a vessel chamber or of the neck of a jar. By using a one-piece mould the two halves of an object can be made identical. However, it is simpler for the potter to use a two-piece mould since it enables the two halves of an object to be joined while still in their moulds, which makes it easier to fix and smooth the seams on the inside

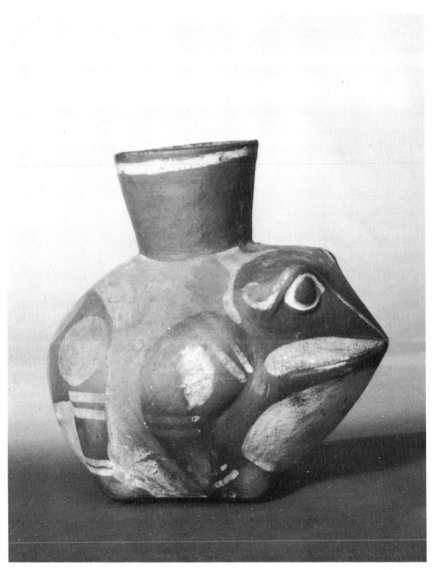

Figure vessel depicting a frog. Frogs were, and still are, part of the native fauna of the river valleys where the Moche lived. 1965-Am-4-1. Ht 22.5 cm.

without warping the vessel. With a one-piece mould the side would have to be removed from the mould to be joined and the seams are subsequently difficult to make. Seams made by this latter process are usually easy to see and they tend to have a rather crude and sloppy appearance. Naturally all the vessels made in this way have an identical design on each of the two halves of the pot.

Coiling
Coiling appears to have been used in conjunction with moulding to make certain parts of pots. The technique of coiling involves rolling out the clay into a long thin sausage-like form which is then wound round like a spring. When the chamber of a stirrup spout bottle was made the lower four-fifths or so was manufactured in a mould but a small hole was left at the top. This hole was then filled by coiling the clay round on top of the already moulded chamber. On spout and handle bottles, stirrup bottles and jars a coil of clay was placed round the neck where it joined the vessel. Similarly, a coil of clay was placed round stirrup spouts where they joined the chamber on stirrup spout bottles, although it was smoothed at the junctures and is difficult to detect. The coiling technique was also used to form the collar on collared bowls and cooking vessels. We are not exactly sure how large storage jars were made but coiling probably played an important part in their manufacture.

Stamping
Stamping was used as a method of ornamentation as opposed to moulding, a method of forming the object itself. North coast Peruvian stamps have been found as well as the matrices from which they were made. Stamps were made of fired clay which had been formed over fired clay matrices (generally showing human or animal forms), or over objects to be represented, such as sea shells and ears of corn.

When stamps were used only one was employed on a vessel; two different stamps are never found on a single pot. The stamps were placed in a symetrical fashion; if one side of a vessel is stamped, then the other is also; or, if the pot is spherical, then an odd number of stamps is placed on it but in an evenly distributed fashion. Jars with a face stamped on to the neck form an exception to this rule since there is only one stamp. Stamps appear only to have been used on jars, collared bowls and stirrup spout bottles.

There are two ways of stamping. Usually the stamp was placed against the outside of the pot while the clay forming the side was still soft and malleable. Then the potter reached inside the vessel and pushed the side out into the stamp. When the stamp was taken away from the outside, the impression was left in the vessel wall. The second way of stamping involved pressing moist clay into a stamp and then pressing the latter against the outside of the vessel. The clay inside the stamp sticks to the vessel and remains attached to it when the stamp is taken away. This method makes it unnecessary to reach inside the pot and in consequence can be done at a late stage in manufacture, especially on vessels like stirrup spout bottles which have constricted openings. There are two important problems with this second method of stamping. First, it is

difficult to make the clay impression stick to the side of the pot. Once the mould has been removed any further attempt to make the stamped impression stick more firmly to the side of the vessel alters the shape of the newly made relief in the soft clay. Secondly, air pockets might be formed between the clay impression and the wall of the vessel, producing an explosion when the pot was fired. To get round this problem deep holes could be punched into the clay impression to prevent air pockets from forming.

Modelling

Modelling, that is direct shaping, was used as a means of elaborating, ornamenting and giving detail to an object. However, modelling was also used in a more functional way to make solid handles which were added to certain vessel shapes. Modelling could involve two processes: the shaping of the clay which is added to an object and the reshaping of the clay which is already part of an object. Handles were made in the first way as were the arms, legs, ear-spools and elaborate head-dresses of moulded figures. Moulding by reshaping the clay which was already part of an object was used as an alternative to the stamping technique and is often seen in the case of low relief faces depicted on jars.

Smoothing

Once the pot had been fully formed and shaped the next process involved smoothing the surface since slight ripples would have been left during the building up process. Several methods of smoothing pottery were used in the Andean area but it is not known which, if any, were used by the Moche potters. These methods involved some means of abrading the vessel surfaces and later rubbing them to give a smooth surface texture. The materials commonly used to abrade the surface of vessels, and which would have been available to Moche potters, include maize cobs, pieces of gourd, bits of bone and rough stones. These or similar materials were probably used to smooth off all the surface ripples after which the pot would be rubbed with either a piece of cloth or leather.

Painting

Painting was done with a slip paint which consisted of a suspension of fine clay in water. The two principal colours of slip paint used were red and white. An organic black pigment was sometimes painted on after firing especially on the Moche style pottery found in the Virú Valley. In painting the desired effect seems to have been a contrast between red and white. The colours were always flat, with no deliberate attempt at shading, although shading sometimes occurred through inconsistencies of firing and polishing. Moche pots tend not to be painted with more than one shade of each colour. On some bottles and jars part of the outer surface was left unpigmented and later polished like the pigmented areas. Red pigments were made from a clay similar to, if not identical with, that from which the vessels were made. However, due to its finer texture and lack of impurities, the pigment can nearly always be

Stirrup spout bottle of an elaborately dressed man holding what could be either a portrait jar or a baby. This figure has been traditionally interpreted as a potter finishing a vessel and more recently as a healer holding a baby as part of a curing ceremony. 1909-12-18-9. Ht 25.5 cm.

Modelled pot showing a woman getting ready to lift a large pot with the aid of a padded net round her forehead. Originally the large vessel on her back may have had a lid, held in place by a string passed through the two holes near the top. 1909-12-18-28. Ht 13 cm.

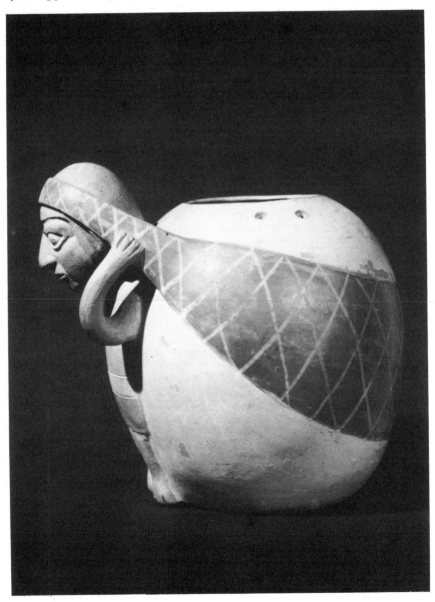

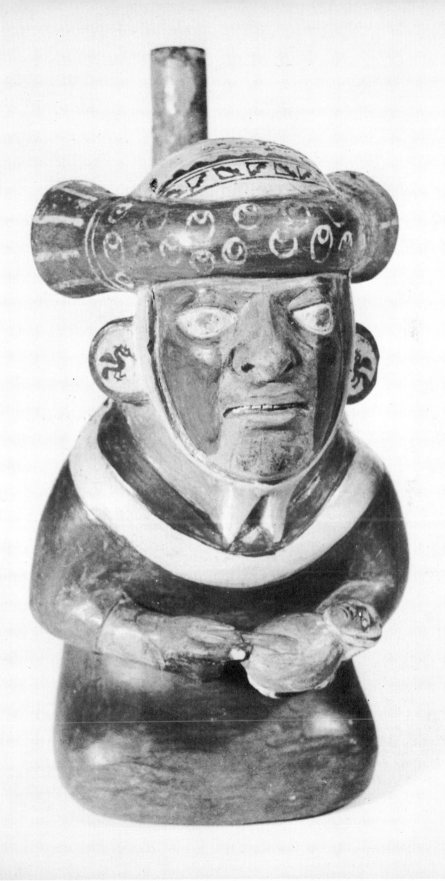

distinguished from the clay of the vessel. White pigments were made from a very fine white clay.

As glazes were not used in pre-Spanish Peru, polishing or rubbing the vessel surface to give it lustre was the most important way of obtaining a fine finish. The standard tool was probably a smooth hard stone. Stroke marks can be rarely seen on the vessel so that polishing was probably done when the pot was nearly dry. Donnan suggests that the pot was allowed to dry thoroughly and the surface was redampened to facilitate polishing. Rubbing the vessel with the hand or a soft cloth also tends to remove the stroke marks.

The most highly polished vessels were generally stirrup spout bottles although other vessel types, such as spout and handle bottles, which had very elaborate decoration, could have a high degree of polish. Generally only the pigmented areas of the pot were polished. Exceptions to this rule are stirrup spout bottles and jars which have polished unpigmented areas.

Incision was quite often used to decorate Moche pots. The most frequent use of this was on stirrup spout bottles and on jars with faces depicted on the neck or the chamber. Incision was almost always done before firing when the clay was quite soft. The potters used three instruments for producing incision and evidence for the use of these can be seen on the pots. First there was the serrated edge of a small cockleshell for making a punctate line. Secondly they used a circular tube, perhaps a bird bone or hollow plant stem. Finally, for making lines and dots a pointed object was employed. Cockleshells were sometimes used to decorate spindle whorls as was the small circular tube. The pointed object for making lines and dots was often used together with stamping and modelling for elaboration, emphasis, or to define certain features such as ornaments or details of dress.

Firing

For the firing techniques of Moche potters it is perhaps best to look at the techniques used by present-day native potters in north Peru. At the pottery-making village of Mórrope near Chiclayo the firing takes place in a shallow pit measuring about two by three metres and some twenty-five centimetres deep. The bottom of the pit is covered with an even layer of broken sticks and branches. First, large jars are placed upright in contiguous rows on the branches. Next another layer of large jars is stacked on the first with the mouths down and positioned so that there is free circulation of oxygen during firing. Bowls and smaller vessels are stacked in two or three layers along the sides and ends of the central pile. The American archaeologist Donald Collier observed, when he visited Mórrope in 1956, that there were 120 pots in one firing and 70 in another. The whole pile is then covered with large potsherds, followed by a layer of broken branches and finally, after the wood has been lit, with a layer of dung. The firing generally takes place in the afternoon and the pots are allowed to cool overnight, after which they can be taken to market. It is likely that Moche pots were fired like this since a number of vessels have localized discolourations which result from contact with fuel during the firing process.

Nearly all Moche pots were fired in an oxidising atmosphere which produced the reddish colour. The pots are invariably of an even colour throughout a cross-section of their walls, indicating a well-controlled firing technique. The combination of temperature, time and draught was adequate for full oxidation but the interior of the stirrup spout is very frequently grey in colour, the result of insufficient circulation of air inside the vessel to oxidise the clay.

Sometimes pots were overfired, that is fired at such a high temperature that the vessels were deformed, the body being softened by too rapid vitrification. The vessels show signs of warping and the slips applied to them are slightly crazed. In the case of stirrup spout bottles the handle may be deformed and off the vertical as a result of overfiring.

Sometimes the Moche made blackware pots, but only in the form of stirrup spout bottles which were not slip painted as is usually the case for this type of pot. Donnan suggests that the firing of blackware pots was probably done in an oxidising atmosphere. Once the temperature was sufficient for sintering to occur, that is for the outer surfaces of the particles of clay to become soft and molten, additional fuel could have been added and the fire covered with sand. The additional fuel would produce smoke, thereby depositing carbon on the surface of the vessel and giving it its characteristic black sheen.

To some Moche pots black pigment was added for decoration. This appears to have been an organic liquid which was painted on the vessels after they were fired. These pots were then heated to scorch the substance under the surface. The application of this pigment was always done positively and no examples of negative painting have been found. Organic black was generally applied to vessels which had both red and white slip pigments and was not generally used to produce a black and red or a black and white design. Black was essentially a secondary design feature used by Moche potters to produce increased elaboration and detail.

Blackware Moche III style stirrup spout bottle with a press-moulded design of a mythical creature holding a trophy head in its right hand and a knife in its left. 1947-Am-10-24. Ht 17.5 cm.

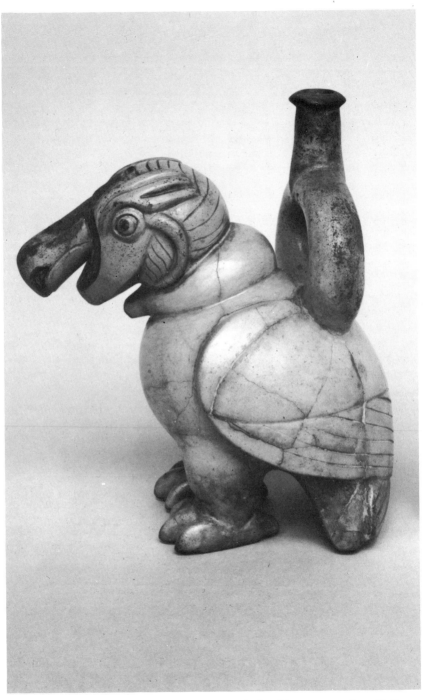

Stirrup spout bottle showing a condor. The flange on the lip of the spout, together with the rather squat and wooden form of the condor, suggests that this pot was made near the beginning of the Moche style, probably in Phase 1. 1938-Am-10-3. Ht 21 cm.

Moche Pottery Types

Stirrup spout bottles

The most common type of Moche pottery in the British Museum collection is the stirrup spout bottle. The earliest stirrup spout bottles, Phase I, have thick walls and are consequently heavy in proportion to their volume. The handles are proportionately circular with short spouts having a big flange on the lip. The modelled vessels show strong links with the late Cupisnique pottery style. The forms are compact and there is little suggestion of movement. Incision is used to indicate details on figures. The faces of people shown are not noticeably individual as in later phases although items of dress and distinctive physical features serve to differentiate figures. Painted designs are not very frequent. The vessel is usually entirely covered with a white slip on top of which a red one is applied. Many of the geometric motifs are similar to or derived from the negative decoration found in the Virú or Gallinazo style. Some Moche I pots have bands whose pictorial themes are outlined by incised lines, a technique similar to that used on late Cupisnique pottery. Some of the Phase I stirrup spout bottles have a stylized cat figure painted in a red on white design. This cat figure is also found, in negative painted form, on some Recuay vessels.

In Phase II the stirrup spout bottles have less thick walls than in Phase I. The size of Phase II pots increases and there is no tendency to give the pot the same height as width. The spout and handle are enlarged in proportion, the handle continuing in its round form while the spout loses its flanged lip so that it only has a vestigial flange. On Moche II pots the painted decoration is mainly geometric although the lines are more refined than in the previous phase. Alan Sawyer, an American archaeologist, has pointed out that low relief is often used in preference to painted decoration, especially to depict mythological scenes or other subjects requiring a suggestion of action. Stamped designs begin to appear on stirrup spout bottles in this phase. The transition from Phase I to Phase II is a gradual one so that there are stirrup spout bottles which can be placed inbetween these two phases. Thus a stirrup spout bottle may have a flanged lip which is not as big as on true Phase I vessels but yet which is smaller than that on Phase II pots.

Just as the transition from Phase I to Phase II is gradual so there is a transition between Phases II and III. In this third phase there was a considerable increase in the amount of pottery and in the number of decorative motifs as compared with the two previous phases. In Phase III the fanged being appears in his most elaborate forms even though his presence has been observed in the two previous phases. On stirrup spout bottles in Phase III the

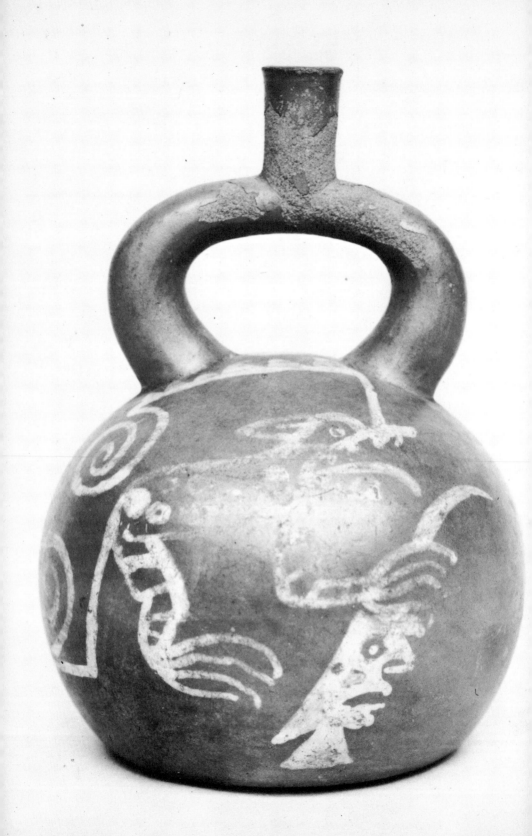

Stirrup spout bottle with a typical Phase III stirrup spout shape. The white painted figure, on an orange background, depicts a stylised feline grasping a trophy head with its front paw. The figure on the base, painted in dark red on a white background, shows a Moche with a cloth head-dress grasping a staff. Painting on the base of a stirrup spout bottle is very rare, and this is the only one so far known. 1933-7-13-60. Ht 20.5 cm.

handles and spouts are refined, the handles being elliptical while the spouts have a short, almost imperceptible, flange early in Phase III which disappears in the latter part of that phase. In modelled pottery there is far more realism than before. True reliefs of people appear, presenting individuals in various realistic positions which range from women having babies to death dances by skeletons. The painted scenes become more animated and the lines are thinner than in the two previous phases. The slips used in this phase are much finer than before. In addition to the red and cream slips orange is sometimes used, although only two colours are employed on most vessels. Sometimes a third colour, fugitive black, is added to the red and white colour schemes to emphasize the main design. Finally a number of highly polished blackware pots are found in this phase. Many of the Phase III stirrup spout vessels show a higher degree of polish than in the previous phases. The scenes painted on stirrup spout bottles include mythical scenes, in which figures combining human and animal features are portrayed, battles, hunts and fishing expeditions.

As in the case of previous phases there was a period of transition from Phase III to Phase IV. Evidence for this has come from graves containing stirrup spout bottles with features of both phases. Compared with Phase III stirrup spout bottles those of Phase IV have bigger and longer spouts with straight sides and the handles are more rounded. In addition there are numerous relief heads, animals and plants depicted on pottery without a stirrup spout handle. Scenic decoration becomes more important in Moche IV than the realistic representation of the previous phase. Painted scenes on Moche IV stirrup spout bottles tend to be adorned with geometric designs. Finally the thickness of line is noticeably reduced in Phase IV.

The expansion of the Moche appears to have begun late in Phase III since pots earlier than this phase are not found in valleys like Virú outside the central Moche-Chicama area. In the fourth phase the Moche people seem to have had their maximum influence extending from Lambayeque in the north to Casma in the south, making a total span of some 200 miles (about 320 kilometres). There appears to have been a strong element of cultural unity, witnessed in the fairly standard style of Moche pottery found throughout this area, although some areas, especially the Virú Valley, exhibit local differences. Towards the end of Phase IV some of this pottery begins to show signs of declining vitality and sloppy execution of painted designs.

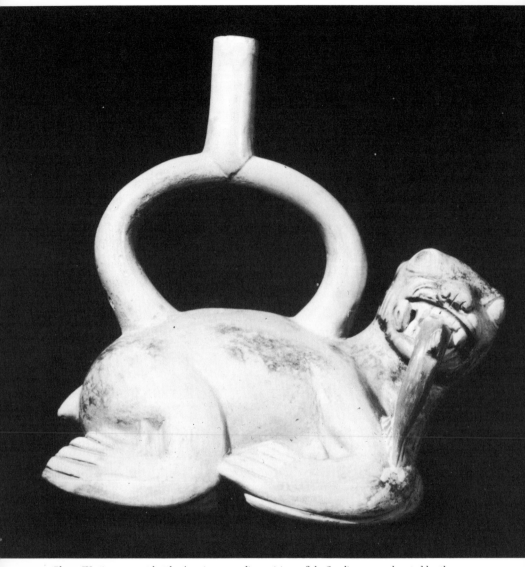

Phase IV stirrup spout bottle showing a sea lion seizing a fish. Sea lions were hunted by the Moche, possibly for the small beach pebbles that are swallowed by sea lions and believed by modern folk healers to have strong curing properties. 1909-12-18-64. Ht 25 cm.

Phase IV style stirrup spout bottle. This shows an anthropomorphized hummingbird holding a drum by a thong in his right hand while his left beats the drum with the other end of the thong. In the background are three vessels including a non-anthropomorphic jar just above the drum. 1909-12-18-107. Ht 29 cm.

Line drawing from a Moche pot showing two anthropomorphized hummingbirds at either end. In the centre is another anthropomorphized being with a snake's tail and a fox's mouth. All three could be messengers carrying marked beans in the bags they are holding. (*After* Joyce, p. 155, fig. 15)

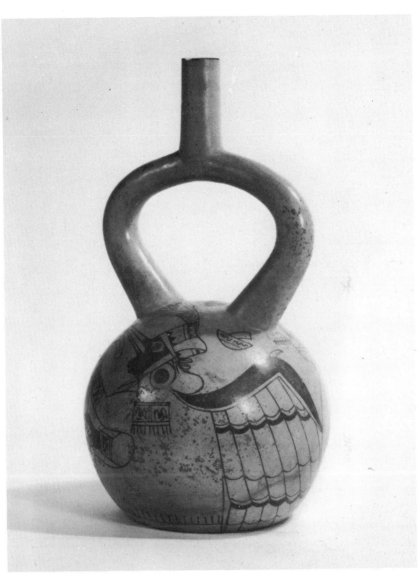

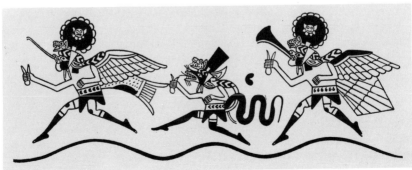

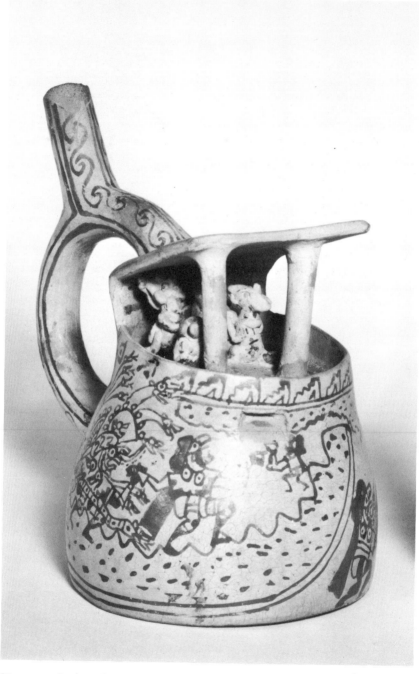

Stirrup spout bottle, probably dating to Phase V. Inside the building a ceremony appears to be in progress with the figure next to the right hand pillar beating a drum. Both front figures have tails while those at the back of the building are human, although one has an elaborate head-dress. 1909-12-18-77. Ht 18.5 cm.

Gradually the Moche stirrup spout bottles of Phase IV became less carefully finished and the sculptural details received less attention. This decline continued into Phase V. In Moche V the stirrup spout bottle handle assumes an accentuated triangular form and the spout tapers towards a thinned lip. The chamber of the stirrup spout bottle is reduced in size although the handle is slightly enlarged. Modelled forms tend to be replaced by fine line geometric designs which generally cover the whole vessel including the handle.

Portrait vessels

Portraiture appeared on Moche pottery with and without stirrup spout handles. The non-stirrup spout form usually consisted of a jar open at the top. The early portrait vessels, from Phases I and II, tend not to be very individual but differences can be seen in the face painting. It was only in late Phase III that portraiture became more realistic. The best examples of portraiture come from the fourth phase (*Cover*); the heads are generally in the form of stirrup spout bottles and average slightly more than half life size. These heads have considerable individuality which suggests that they may have been made from life, but we do not know exactly who is represented. Some very striking heads reoccur many times and it is suggested that the men shown are in fact Moche rulers although there is no firm evidence for this. Some portrait heads have puma skin head-dresses which may indicate that the wearers were in some way connected with the worship of the fanged being who appears on pottery. In the Museum für Völkerkunde in Berlin there is one vessel which shows a fanged being wearing a puma skin head-dress.

Figure vessels

These often take the form of stirrup spout bottles although there are some examples which have a jar neck rising from either the top or the back of the head. The range of subjects shown is considerable. The heads of these vessels are usually disproportionately large and often the faces are carefully treated so that they show individual differences like the portrait vessels. In this category and in the portrait vessels one can see a wide range of physical types. Some pots show thick lipped Negroid types while others have more Mongoloid characteristics like 'slit' eyes. Other figures could easily be mistaken for Europeans. These racial variations are probably just natural variations in the existing American Indian population of Peru at that time. Similar differences have been noted in the art of ancient Mexico which was also peopled by American Indians.

Figure vessels often show people with physical deformities, such as hunchbacks and dwarfs, or those suffering from diseases. The diseases shown include those of the skin – people with scabs on their skin are depicted suggesting leprosy – and blindness is often represented. Larco Hoyle has suggested that some of these vessels show smallpox but this is unlikely since the disease appears to have been introduced into Peru in the sixteenth century. Various forms of cretinism occur such as that associated with goitre, and cretins are shown with club feet. Evidence of surgery is provided by figure vessels showing people with amputated limbs and sometimes people with

amputated feet are depicted riding llamas. Examination of skulls from Moche graves has shown that trepannation, the cutting of a small piece of bone from the skull, was performed with shark's teeth instruments. Some figure vessels show people who are kneeling beside a sick person suggesting that they are trying to effect a cure, possibly by exorcising a spirit. A study of the village of Moche done in 1944 showed that professional curers were sometimes consulted when people were sick. This practice continues today so presumably the curers on the figure vessels were performing similar functions.

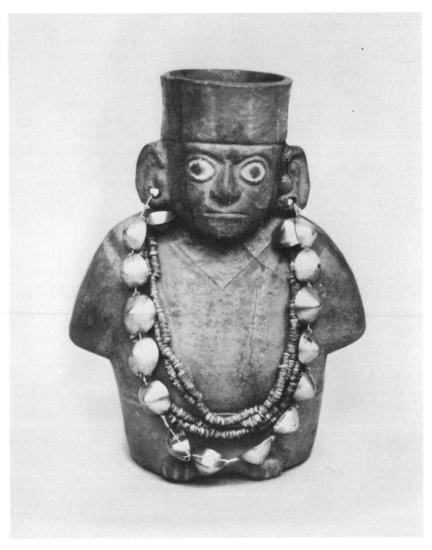

Figure vessel showing a man with arms severed at the elbow. The hands and forearms have probably been deliberately cut off. The holes in the ear lobes suggest a person of noble rank. Attached to his ear lobes are three strings of shell beads and a necklace of cone-shaped silver ornaments. Q-79-Am-1. Ht 20 cm.

Both the modelled and painted figures give a good idea of how the ancient Moche dressed, although few of the actual fabrics have survived due to the unfavourable conditions for the preservation of organic materials on the north coast. In the British Museum there is a flaring dish which shows weaving being done by women and, since there are no representations of men making clothes, one can assume that most clothes were probably made by women.

The head-dresses shown on figure vessels confirms the observation of one Spanish chronicler, Cieza de León, that the coastal peoples were wrapped up

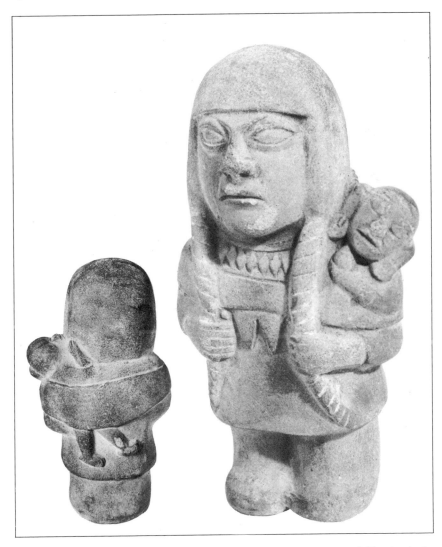

Figurine of a Moche woman, holding a plait of hair in each hand, carrying a child on her back in a shawl. The child has ear rings which suggests it might be of high rank. Covered with a red slip but unpolished. The basic form was probably made in a mould with the finer details being finished off by modelling. 1909-12-18-4. Ht 15.5 cm.

like gipsies. One type of headgear consisted of a small cap around which fine strips of cloth embroidered in colours were wound like a turban. This outfit was then fastened with a rather broad cloth, usually undecorated, which ran diagonally across the crown and was tied under the chin while a padded neck-piece fell down over the shoulder. All this was necessary to protect the wearers against the hot sun and desert sand.

Most information is given about men's clothes since women appear to have occupied a relatively unimportant position in these representations. The men's

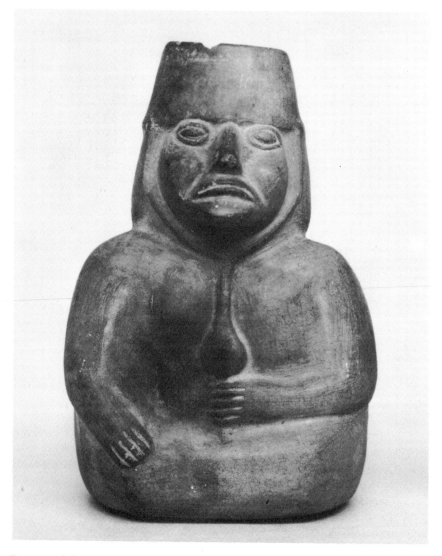

Figure vessel showing a seated person, probably a woman, wearing a cloth head-dress which is tied at the back of the head as well as under the chin. Covered with an off-white slip. 1947-10-19. Ht 20 cm.

most important garment was a loin-cloth which was pulled up between the legs. The upper part of the body was covered with a short and frequently sleeveless shirt while on top of the loin-cloth was worn a kind of short skirt held in place by a wide belt, sometimes decorated with rattles. Large collars, rather like Elizabethan ruffs, were sometimes worn. Finally, male attire could be completed with a large cape which was knotted on the chest. Legs and feet were usually bare except for warriors who appear to have had theirs painted. Women seem to have worn a loose fitting tunic which reached to the knees. No sandals appear to have been worn and the modern inhabitants of Moche are quite happy to dig their fields in bare feet.

Jewellery usually consisted of ear ornaments in the form of simple plugs of large discs which were inserted through holes in the ear lobes or disc-shaped appendages which were generally fastened to the ear by a ring passed through the ear lobe. Sometimes a nose ornament, shaped like a crescent or a moon, was attached. Heavy chains were sometimes hung round the neck. Some figures are shown with cuffs of alloyed gold and sheets surrounding the forearm. Face and limbs were painted just like the legs and some of these Moche figure vessels show tattooing.

Warriors
Warriors often feature on figure vessels and also in painted scenes on stirrup spout bottles. They are shown wearing a simple tunic, with some ornament, which is belted at the waist and sometimes has short sleeves. The design on the tunic is usually geometric and metal discs and plates are added for decoration and armoured protection. Clubs, the chief fighting weapons, had a heavy head and, sometimes, a copper spike attached to the handle. Since helmets had to withstand blows from such clubs they had to be quite strong. The most common type of helmet was made of wood, leather and copper, was well padded, and had an armoured neck-piece and chin-strap to which ornamental ear protectors were attached. Some warriors are shown wearing a well-padded turban, at times covered with animal or bird skins.

Besides belts and tunics warriors generally wore protective collars and ruffs. An object shaped like an axe blade is shown attached to the back of the belt and these appear to have been made of copper, wood and leather. Gilded copper fittings have been found which seem to be clasps to attach these tailpieces to the belt. Warriors had their faces, arms and legs painted but they do not appear to have worn knee caps and long stockings as the painted designs might suggest.

Modelled pots of warriors frequently show them on one knee, holding their clubs and shields to the front. On painted vessels they feature in ceremonial processions or in scenes of combat. Generally the combatants are dressed in a similar fashion, inferring that different groups of Moche were fighting each other. Sometimes there are differently dressed groups of warriors shown fighting each other, suggesting a non-Moche group, dressed in a foreign costume, fighting a Moche group, attired in typical Moche warrior's dress. Weapons for use at a distance included throwing sticks, darts and slings while

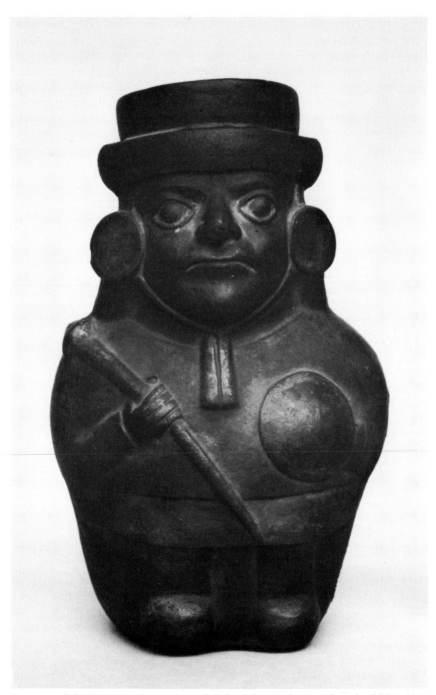

Figure vessel showing a warrior wearing a cloth head-dress and ear spools. In his left hand he carries a shield while in the right he holds a club. The latter would probably have been wooden but may have had a copper spike on the pointed end. (*See also* front cover) 1947-Am-10-10. Ht 23 cm.

for fighting at close quarters there was the heavy headed club. This weapon would have been used like a modern soldier uses his bayonet and rifle butt.

Moche warriors are sometimes shown with some features of the fox or hawk. Usually these representations appear in painted scenes where the warrior may be shown wearing a fox mask or he may have the beaked nose, wings and tail of a hawk. It is not always possible to say whether a warrior with what appears to be a fox mask and tail is in fact a 'fox warrior', or whether he is just a symbolic anthropomorphic representation. Similarly, a warrior

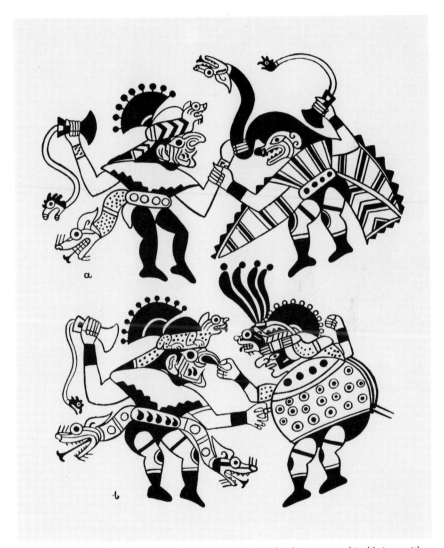

Line drawing from Moche pots depicting supernatural combat between mythical beings with human and animal features. In the upper scene the being with the snake-headed belt appears to be winning since he has his opponent by the hair. (*After* Joyce, p. 127, fig. 10)

with just a hawk-like face and a beak nose may be wearing an actual face mask or be just symbolic for a hawk. Some Spanish chroniclers relate how they saw Indians dress up in animal and bird skins.

Economy

The Moche showed, both in painted and modelled pottery, many of the plants which they ate. Besides maize, potatoes appear although these were more likely to have been grown in the cooler and damper highlands whence they

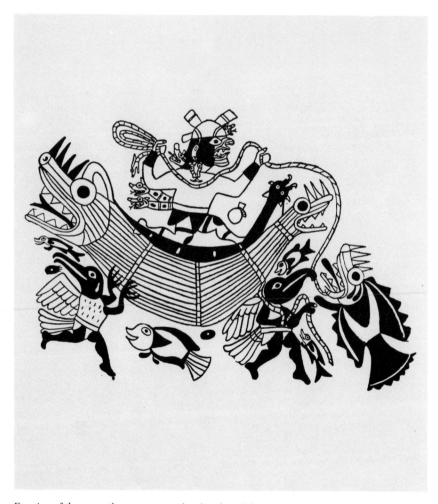

Drawing of the scene that appears on the chamber of the stirrup spout bottle *opposite*. It shows a person, with a double-headed snake belt, on a reed raft casting a line to catch a fish. The double-headed raft is being pulled along by a bird creature. The whole scene would appear to be mythological, showing a deity on the raft on a fishing expedition. (*After* Joyce, p. 126, fig. 9)

Stirrup spout bottle in Phase IV style. The painted scene, executed in dark red paint on a cream base, appears to be a mythological fishing expedition. 1909-12-18-119. Ht 30 cm.

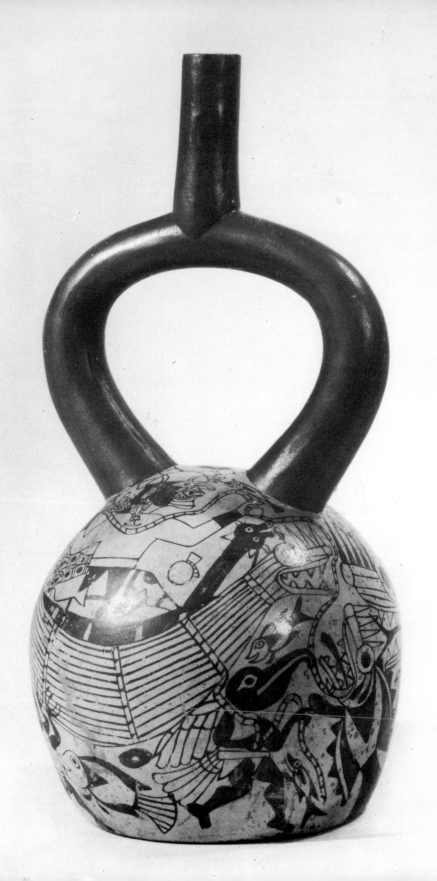

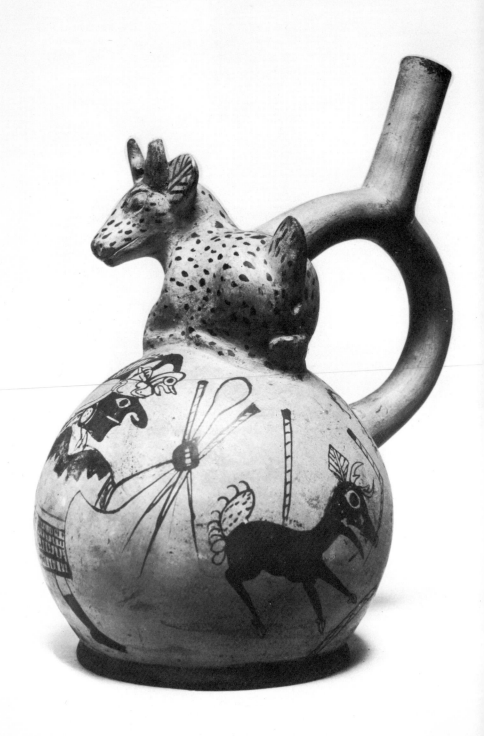

Stirrup spout bottle depicting a modelled and painted deer on top and a painted scene of a deer hunt below. The deer is being hunted by an elaborately dressed Moche armed with darts and a club. 1909-12-18-66. Ht 21 cm.

Stirrup spout bottle (stirrup and spout handle missing) of a llama with a pack on its back. This could depict a coastal breed of llama with a shorter neck than its highland counterpart. The Moche mainly used llamas as pack animals but also occasionally for their meat and in sacrifices. 1933-7-13-58. Ht 16 cm.

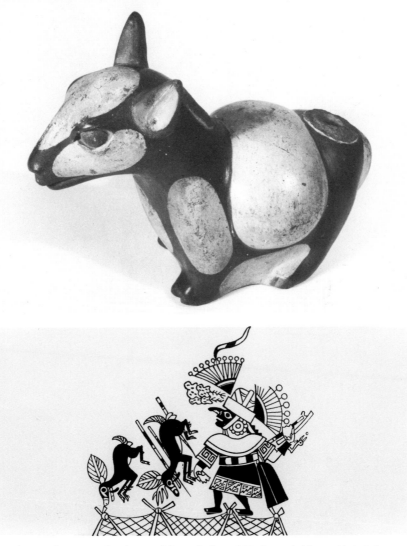

Line drawing from a pot showing an elaborately dressed Moche, probably a noble to judge from his ear spool, killing deer that have been driven into nets. In his left hand he holds a spear thrower and a spear. (*After* Joyce, p. 124, fig. 8)

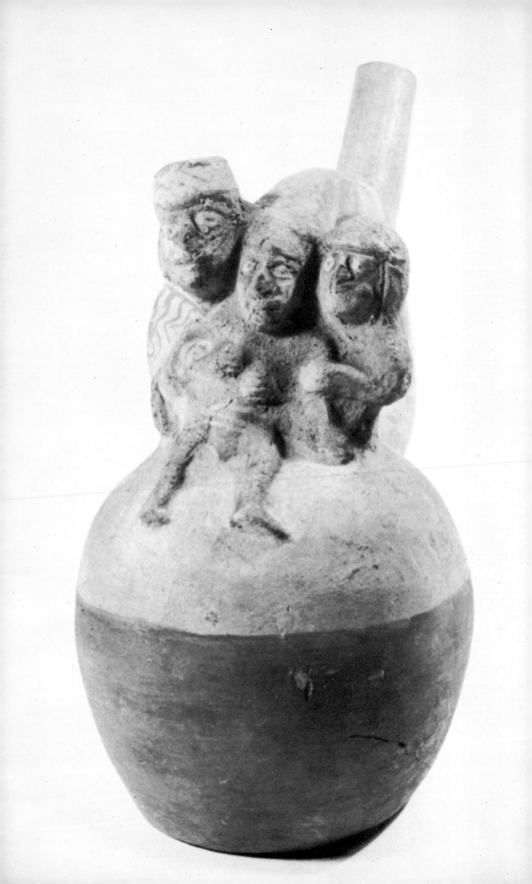

Stirrup spout bottle with a modelled scene on top showing a drunkard being helped along by two companions. The drunkard has probably been imbibing *chicha*, of which great quantities would have been drunk at festivals and also certain communal activities, such as cleaning the irrigation ditches. The weathering on the surface is caused by salts coming out of the pottery and making the red and white slip paint flake off. Originally the whole surface would have been covered with slip paint as can be seen on the left hand figure. 1909-12-18-47. Ht 20 cm.

could be sent to the coast. Also we see representations of manioc, squash and peppers. These latter four plants were introduced to the north coast about a thousand years before the Moche became established there.

The Peruvian coastal waters have been rich fishing grounds for at least ten thousand years so that Moche pots naturally depict fishing scenes. In addition to the modelled pots showing the *caballitos del mar* from which one or two men could fish, there are painted scenes depicting angling lines or nets being used from the shore.

Besides plants and fishing scenes we have representations of hunts and food gathering expeditions. The painted scenes of deer hunts usually show many beaters or small spotted dogs driving the deer out of their hiding places into widely stretched out nets to be killed with spears and clubs. The hunters who despatched the deer are shown as elaborately dressed people, presumably of high rank. Probably only the Moche nobility were allowed to kill deer as was the case in the Inca Empire. Food gathering could involve the collection of land snails which were edible after a depoisoning process. Domestic animals like the llama featured mainly on modelled vessels. Llamas are sometimes shown carrying men who lie with their head over the tail and feet round the neck, but llamas cannot carry adults for any distance, so these rides must have been only for a short way. There is a report that llamas were used for crossing the Santa river and it is possible that the Moche employed a coastal breed of llama which was slightly smaller than its highland counterpart. The other principal domesticate of the Moche was the dog. In addition to domestic animals some wild animals like young pumas were kept as pets.

The most important drink was a kind of maize beer, called *chicha*, which was fermented in large jars. Large quantities of chicha were and still are drunk at Indian festivals in Peru as well as stronger intoxicants. Drunks occasionally feature on modelled Moche pots. Besides chicha the Moche showed that they appreciated *coca*, from which the drug cocaine is extracted. The coca leaves were dried and preserved in a little pouch from which they were taken and placed in the cheek. The leaves were activated with lime that was kept in a gourd and removed with a small spatula.

Religion
The Moche appear to have had a strong belief in life after death. Evidence for this is provided by their careful burial methods and numerous grave furnishings which included fine modelled and painted pottery. Scenes, painted

41

and in relief, on pottery show skeletons sometimes making love while at others they are playing musical instruments like the flute and tambourine. Hollow canes have been found leading from some tombs to the surface which suggests that the spirits of the dead may have needed nourishment from the living.

For the religion of the living we have numerous representations of the fanged being in his various guises. Human sacrifice was practiced in which the victim is shown in a kneeling position while the deity or priest, often shown atop a pyramid, kills him with a *tumi*, a ceremonial knife. Such a scene of

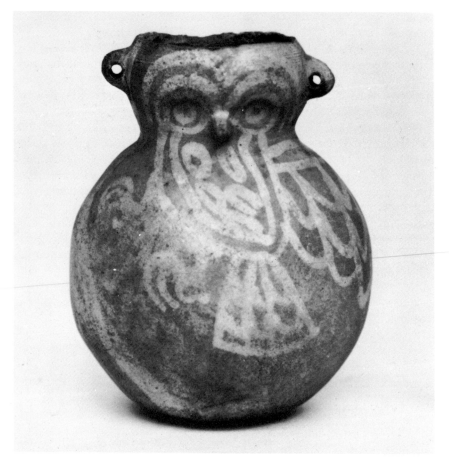

Face-neck jar with the head of an owl modelled and painted on the side of the neck while its body is painted in white slip on the chamber. A modern folk-healer in Moche regards the owl as symbolizing, amongst other things, the spirits of the dead. Possibly the ancient Moche associated the owl with death. 1921-10-27-44. Ht 17.5 cm.

Stirrup spout bottle showing an anthropomorphized owl, modelled and painted in white and red slip. In his left hand he is holding a human trophy head which would have been cut off with a *tumi*. This could represent a man with an owl mask who has just sacrificed a human being. 1954 W.AM.5.4 Ht 22.5 cm.

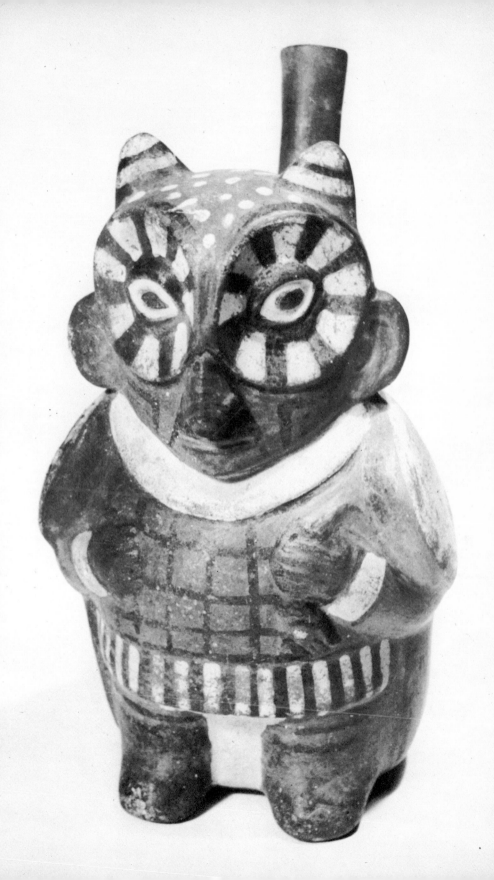

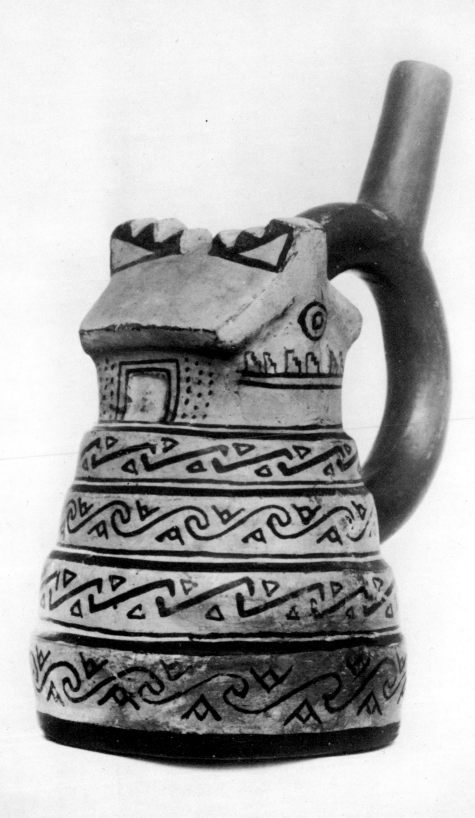

Stirrup spout bottle showing a structure with a double step roof decoration and a door. The circular lower part of the pot may represent a pyramid. This type of structure was probably for religious rather than domestic use. 1909-12-18-78. Ht 20 cm.

sacrifice appears on a pot in the Museum für Völkerkunde in Berlin where an owl demon is shown killing a victim with a *tumi* knife on top of a pyramid. Sometimes deities are shown carrying trophy heads. The supreme deity of the Moche was most likely the moon. There is a written record from Antonio de la Calancha that the Chimú, several hundred years after the Moche and in the same region, worshipped the moon as their supreme deity. In painted scenes on Moche pots the moon god appears surrounded by a crown of beams. The moon is shown crossing the heavens by night in a great crescent-shaped boat, containing jars and prisoners to be sacrificed. Other painted vessels show the waning moon crescent itself, and the moon can appear in a litter accompanied by numerous servants in the form of animal demons.

Non-stirrup spout pottery types

Besides the stirrup spout bottle and portrait jar the Moche placed other vessels, both utility and non-utility, in their tombs. The utility vessels were usually cooking pots, often with a round base and short neck, or storage jars, which usually had longer necks and could be as much as three feet (one metre) high. Cooking pots can be recognised since they invariably have signs of sooting on the base. Some of these utility vessels were decorated by punching holes in the side of the neck to make a face, an idea that may well have derived from the Gallinazo or Virú culture.

Many of the decorated non-stirrup spout vessels found in tombs do not show obvious signs of use. At the Huacas Sol and Luna Max Uhle excavated many non-stirrup spout vessels which may have been specially made for funerary use. One very common form is a non-anthropomorphic jar which has a body closed by a neck. These jars vary in their dimensions and designs over a period of time. Thus those jars which are found associated in the same grave as Phase IV stirrup spout bottles tend to be smaller than jars found in graves containing Phase III stirrup spout bottles. Phase III jars are often decorated with stamped designs, set on the chamber, while in Phase IV stamped jars are very rare. The painted designs on Phase IV jars are usually done in thinner lines than those on Phase III examples.

Besides the non-anthropomorphic jars the Moche made jars with a face in relief set on the neck. These, termed face-neck jars, sometimes have the eyes accentuated with incisions. The ears were modelled onto the side of the head. The jar chamber usually depicts the hands but not generally the feet. Hands are shown in painted form, with the fingers sometimes incised, and are usually

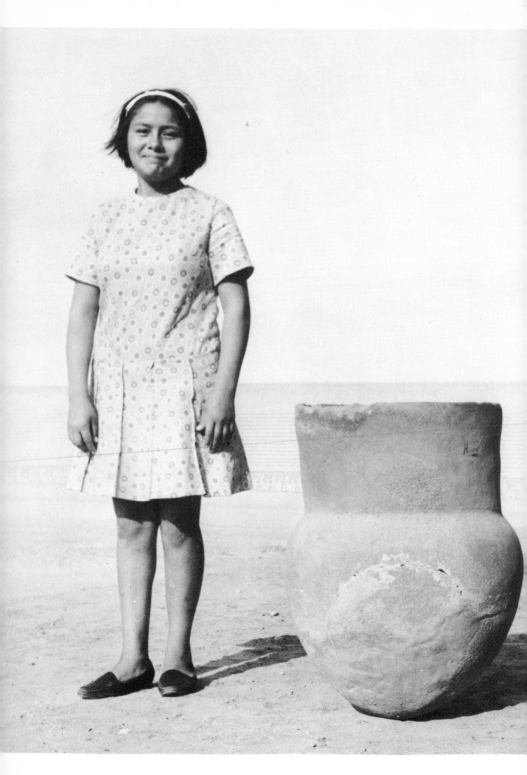

slightly raised from the chamber wall. Shoulders are shown in profile. As in the case of non-anthropomorphic jars, these face-neck jars show changes as between phases III and IV. In Phase III the face is usually painted a shade of red or orange with white eyeballs while in Phase IV the face tends to be decorated with thin line geometric designs such as red and white ones round the eyebrows.

After the jars the most common non-stirrup spout form is the flaring dish, a vessel with a flat or ring base and concave flaring sides. In Phase III the flaring dishes tend only to have flat bases whereas in Phase IV they can have ring bases or bases with rattles, usually hardened clay pellets, placed inside them. Phase III flaring dishes do not have the inside of the rim decorated as do Phase IV examples, such as one with women weavers. Finally, pressed relief designs are found on the exterior of Phase III flaring dishes but not on the exterior of Phase IV examples, which always have painted designs on the outside. The painted designs on the inside of the rim of Phase IV flaring dishes bear direct comparison with the painted designs on stirrup spout bottles of the same phase in that thin red lines are used to depict scenes on both categories of vessel.

Flaring dish with a ring base. Both the style of geometric painting on the exterior and the frieze of foxes on the inside of the rim point to Phase IV of the Moche style. 1909-12-18-217. Ht 19.5 cm.

Large storage jar or *olla* from a Moche period tomb at Huanchaco, near Trujillo. This would have been used for storing liquids like *chicha*. The jar is of plain red ware 73 cm. high. The girl standing beside it is of Peruvian Indian stock.

47

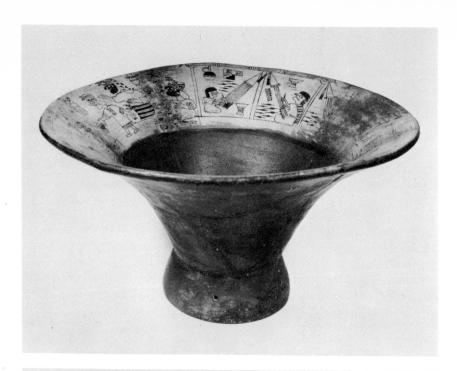

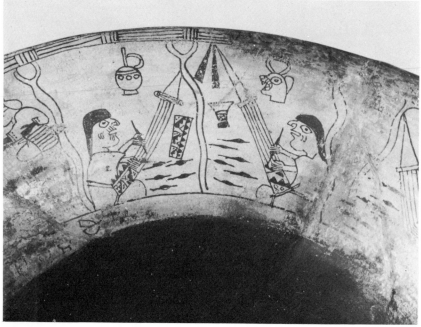

Flaring dish and a detail of its painted frieze showing women weaving elaborate cloths, probably head-dresses, on backstrap looms. Each is shown with one end of the loom attached to a post while the tension is maintained by the other being held by a belt round the waist. 1913.10-25-1. Ht 18.5 cm.

Similar types of animals such as pelicans and deer appear on both painted stirrup spout bottles and the inside of flaring dish rims.

A less common type of non-stirrup spout pot is the dipper, a saucepan-like pot with a hole in the top and a rounded base. Dipper handles can be plain or they can have human or animal heads on the end. In tombs containing dippers with Phase III stirrup spouts the dippers often have the base left plain while the upper part is painted with a geometric design. In Phase IV tombs the base of any dipper is usually painted in Phase IV style. In order to show off the design on the base of Phase IV dippers the shoulder is set higher than in the previous phase.

Besides these forms the Moche made double-chambered whistling bottles. These consisted of two chambers one of which has a spout set on top while the other generally has a bird, with a whistle in its beak, on top of the chamber. The two chambers are joined together by a bridge-like handle so that when one blows down the spout a whistling sound emerges from the bird.

Finally there is the spout and handle bottle which can have a number of forms. Some of these vessels have a simple vertical spout with a strap handle set on top of the chamber. Other vessels can have a stirrup spout handle attached to the lower end and a figure, human or animal, rests on top of the chamber. Both types are represented in the British Museum collection.

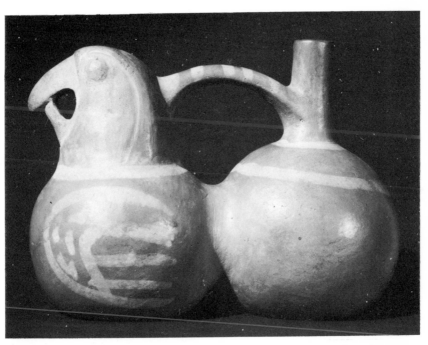

Double chambered whistling bottle in the form of a macaw. If liquid is poured into the spout and the whole vessel is then tilted, air is forced through the mouth and produces a whistling sound. 1938-5-7-2. Length 20 cm.

The Use of Pots

There has been considerable speculation about the possible use of stirrup spout bottles as water containers. However if one puts water into them and tries to pour it out the result is not very satisfactory since it only pours very slowly. Also, if the chamber is full of water and the bottle is held by the handle the latter is apt to drop off with the weight. Donnan's experiments together with the radiographic analyses carried out on British Museum stirrup spout bottles have shown that the stirrup spout was added to the chamber and not made as an integral part. This process may partly account for the tendency of stirrup spout handles to come away from the chamber. The most likely explanation for stirrup spout bottles is that they were essentially decorative vessels with an artistic rather than a utility function. They seem to have been kept in houses by

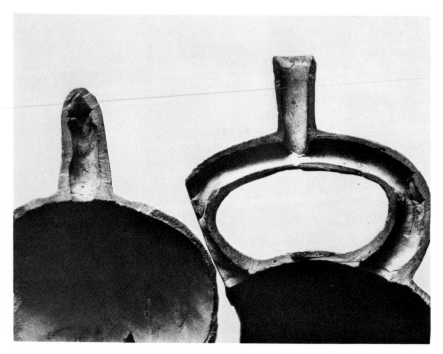

Two cross-sections of Moche pots. The right hand one shows how the stirrup spout handle has been joined to the upper part of the chamber. The stirrup spout would have been added after the chamber had been made. That on the left illustrates a protuberance that has been joined to the chamber of the pot.

the Moche just like commemorative china on the mantlepiece and in display cabinets in homes today. Some Moche pots show people carrying stirrup spout bottles by the handle but they are not shown drinking from them. The scenes showing ceremonial drinking indicate that bowl-shaped vessels were used but these could have been made of copper. For ordinary purposes gourds served as drinking vessels.

Flaring dishes do appear to have had a definite use since there is one pot, not in the British Museum collection, which shows a woman washing her hair into a flaring dish which lacks any decoration. It is unlikely that finely painted examples would have been used for this purpose but they may have had a ritual use.

Dippers sometimes appear on modelled pots where they are shown being carried. However the decorated examples found in graves show no signs of use. It is possible that this type of vessel was used as a container for food but the exact use remains uncertain.

Some modelled pots show utility jars with wide mouths, short necks and round bases. One such pot in the Brüning Museum, Lambayeque, shows a woman pouring from one of these jars into a bowl which is being stirred by her companion. Another jar stands at the side of the bowl. Complete examples of these jars have been found in Moche tombs and fragments are frequently found on habitation sites. They were probably used for liquids. The decorated non-anthropomorphic jar also appears on pottery scenes, often with a tie round the neck. These jars, with their flat or ring bases, could have been used for storing liquids even though there are no deposits left inside their chambers. One Phase I stirrup spout bottle in a private collection in Basle shows a llama with two panniers, each containing a jar with a cord round its neck. Jars similar to these are still being made near Piura and are carried to market in Catacaos in panniers borne by donkeys which have replaced llamas in north Peru.

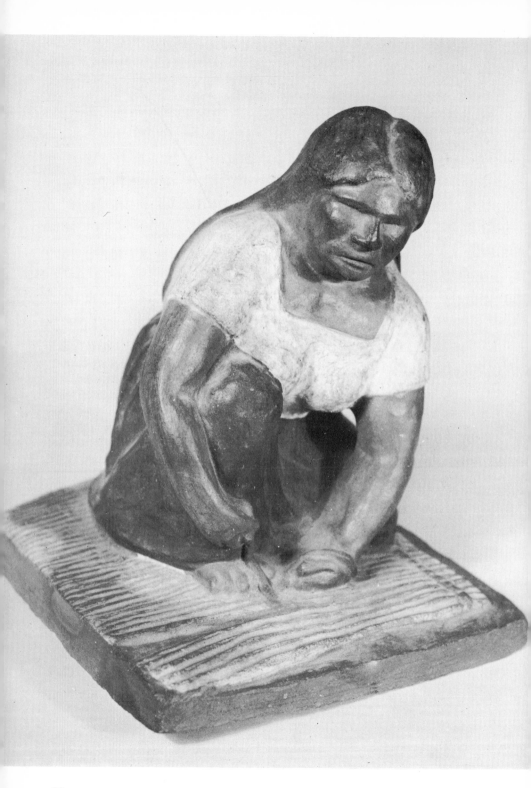

Moche Pottery Today

The modelled tradition of ancient Moche pottery can still be seen today in the work of Eduardo Calderón who works in Las Delicias, close to the modern settlement of Moche. He makes modelled vessels which show, for example, Moche women grinding maize and making reed mats. For polishing he uses the plastic end of a ball-point pen. The colours are basically red and white. He signs his work with his name, date and place of work which is something the ancient Moche did not do. Calderón only makes modelled vessels and does not produce the plain cooking and storage pots. On the north coast these are now only made in two villages, one near Chiclayo and the other near Piura, both of which produce only utility vessels. It is possible that this pattern of a craft potter making modelled and painted non-utility pottery while others made the ordinary utility vessels may have pertained in antiquity. Certainly if one looks at the ancient modelled and painted Moche pots they do exhibit consummate skill which was probably only possessed by a limited number of people. It is quite likely that there was some division of labour with the craft potter turning out fine stirrup spout bottles while others produced the utility vessels. Some of the fine painted and modelled vessels are almost identical, suggesting that they are the work of an individual artist.

Signature on the base of the pot showing the woman making the mat. It reads:
Eduardo Calderón P.
Deliciás-Moche-Perú
1969

Modelled and painted pot, in white and two shades of brown, depicting an Indian woman from the community of Moche making a *totora* reed mat. Made in 1969 by Eduardo Calderón P. in Moche. Calderón is also a well known *curandero* or folk healer. Private Collection. Ht 22 cm.

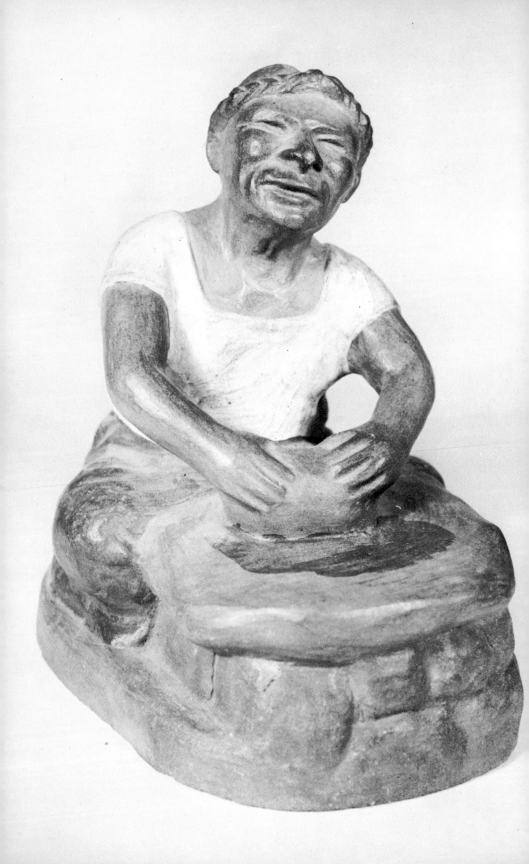

Select Bibliography

BANKES, G. H. A. 'Settlement Patterns in the lower Moche Valley, north Peru, with special reference to the Early Horizon and Early Intermediate Period'. In *Man, settlement and urbanism*, ed. by Peter Ucko, Ruth Tringham and G. W. Dimbleby. London, 1972.

BANKES, GEORGE. *Peru Before Pizarro*. Oxford, 1977.

BENSON, ELIZABETH, P. *The Mochica*. London, 1972.

DIGBY, ADRIAN. 'Radiographic examination of Peruvian pottery techniques'. In *Actes du XVIIIE Congrés des Americanistes*, pp.605-8. Paris, 1948.

— 'The technical development of whistling vases in Peru'. In *Civilizations of Ancient America* (Selected Papers of the International Congress of Americanists), pp.252-7. Chicago, 1951.

DONNAN, CHRISTOPHER B. 'Moche Ceramic Technology'. In *Ñawpa Pacha* 3, pp.115-38. Berkeley, 1965.

— *The Moche Occupation of the Santa Valley*. Berkeley and Los Angeles, 1973.

— *Moche Art and Iconography*. Los Angeles, 1976.

JOYCE, T. A. *South American Archaeology*. London, 1912.

KLEIN, OTTO. *La Ceramica Mochica*. Valparaiso, 1967.

KROEBER, ALFRED L. *The Uhle Pottery Collections from Moche*. Berkeley, 1925. Reprinted New York, 1965.

KUTSCHER, GERDT. *Ancient Art of the Peruvian North Coast*. Berlin, 1955.

LARCO HOYLE, RAFAEL. *Los Mochicas*. 2 vols. Lima, 1938-39.

— *Cronología arqueologica del norte del Peru*. Buenos Aires, 1948.

LUMBRERAS, LUIS G. *The Peoples and Cultures of Ancient Peru*. Translated by Betty Meggers. Washington, 1974.

SAWYER, ALAN R. *Ancient Peruvian Ceramics. The Nathan Cummings Collection*. New York, 1966.

TELLO, JULIO C. *Arte Antiguo Peruano, Primera Parte, tecnología y morfología*. Vol. II: *Inca*. Lima, 1924.

WILLEY, GORDON R. *An Introduction to American Archaeology*. Vol. 2: *South America*. New Jersey, 1971.

Modelled and painted pot, in white and two shades of brown, showing a modern Indian woman from the community of Moche. Her hair is plaited and she is using grinding stones, the large base one being called a *batan* while the small hand-held one has been termed a *mano*. Made in 1969 by Eduardo Calderón P. in Moche. Private Collection. Ht 25 cm.